STAINED GLASS

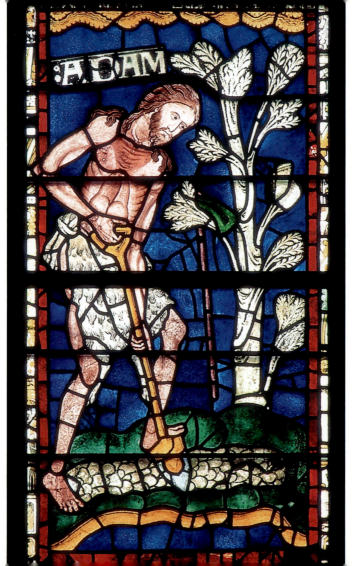
ADAM

A LITTLE BOOK

OF

STAINED GLASS

Text and Photography by

Mike Harding

AURUM PRESS

First published by Aurum Press Ltd,
25 Bedford Avenue, London WC1B 3AT

Text and Photography copyright © 1998
Mike Harding

A catalogue record for this book is available
from the British Library

ISBN 1 85410 564 7

Printed in Belgium by Proost

Facing title page – Adam digging, the great east window, Canterbury Cathedral
Title page – A saint in a fragment from Ripon Cathedral
Above – Star fragment, Ripon Cathedral
Opposite – Burne-Jones window, Brampton, Cumbria

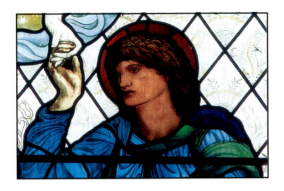

So the glass took hold of the light
And spun it with threads of the cobalt sky,
And the ruby floss of the dying sun.
Then with a shuttle of lead calms,
A weft of pot metal
And a warp of molten sand and ash,
It wove the brittle, fragile cloth of glory.

Poem by the author

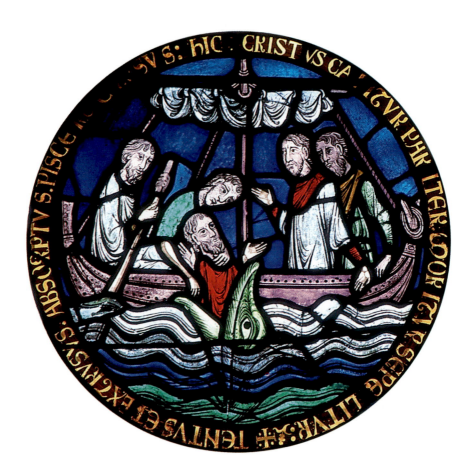

INTRODUCTION

A man that looks on glass, on it may stay his eye;
Or if he pleaseth, through it pass, and then the heavens espy.
George Herbert, 'The Elixir', *Selected Poems*, Penguin, 1973

❖

According to Pliny the Elder (AD 23–79) glass-making was discovered by Phoenecian sailors while they were camping on the shores of the river Belus in what is now modern Israel. Their cooking pots were placed on lumps of soda rock on the sandy shore of the river and, while they were cooking, they noticed that where the soda rocks and the sand met close to the fire a 'strange translucent liquid poured forth in streams; and this it is said was the origin of glass' (Pliny, *Historia Naturalis*.)

In the beginning glass was produced therefore by the simple method of fusing together silica in the form of sand and alkali in the form of ash made either by burning wood or sea weed.

Once melted the glass was poured into moulds and, since it could be cast and worked on in a similar way to metal, much of the very earliest glass was used in the making of ornaments, eating and drinking vessels and jewellery.

The invention of the blowpipe sometime in the middle of the first

century BC, meant that glass could be blown and spun into cylinders which could then be cooled and flattened into panes, a technique which is still employed today by traditional glassmakers. The later invention of leading (the insertion of strips of lead to hold together small pieces of glass into one pane) meant that glass started to become a major feature in building design.

We don't know at what point men discovered that adding quantities of metal oxides to the glass produced brilliant colours (cobalt giving blue, copper green, iron red and so forth) but we do know that by the fourth century AD, the basilicas in Constantinople had 'glass in colours without number' according to the Spanish poet Prudentius (AD 348–410).

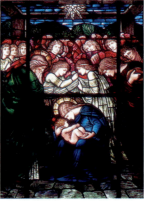

By the early Middle Ages, not only had the craft of making stained glass been refined to an art but the technique of painting on the coloured glass with black oxides, which were then fused into the glass in an oven, had been discovered, so that what we now call stained glass should more properly be called stained and painted glass.

The great medieval windows such as those to be seen in Canterbury and Chartres Cathedrals were created in workshops close by the cathedrals where teams of glaziers would blow the 'pot metal' (as the molten coloured glass was known) into cylinders then flatten and cut them into small 'quarries'. These were then placed on a design drawn on a whitewashed wooden table and cut and nibbled into shape with

'grozing irons'. Any detail to be painted on was then brushed onto the glass and fused onto the surface in small kilns after which the glass was fixed into the lead strips or 'calms'. When the window was finished it was offered up into the space and fixed in place by saddle bars, rods of iron mortared into the stonework.

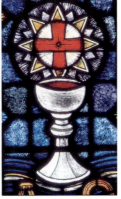

The greatest period of glass-making was without doubt the Middle Ages and the windows of Chartres and the Sainte Chapelle in France and those of Canterbury and York in England are wonderful examples of the truly inspired genius of the medieval craftsmen.

The painting of Jonah being thrown to the whale and the fragment of the Tree of Jesse on the previous pages are both from the wonderful medieval windows at Canterbury Cathedral.

The genius of the medieval glass-maker was revived in more recent times in the Pre-Raphaelite workshops of William Morris, and it was from his legacy that the vision of later glass-makers of genius such as Harry Clarke developed such strength and power. The Nativity scene on the facing page is from a lovely set of windows in Winchester Cathedral designed by Burne-Jones for the William Morris workshop.

This little book is a very personal choice of glass drawn mostly from those two periods, the Middle Ages and the Late Victorian years. There is little modern glass in this book simply because I feel that modern glass-makers, with a few exceptions (such as Jane Grey who painted this chalice; see also pp. 26–27) like modern architects, seem very much to have lost their way.

ST GEORGE & THE PELICAN

❖

St Martin, Brampton, Cumbria

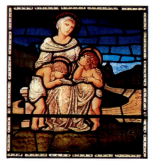

Perhaps the best example in England of the partnership between William Morris and Burne-Jones the glass in this church is of world-wide significance.

The expansion of transport in Victorian England meant that artefacts from countries like China and Japan found their way to England in much greater quantities than previously. It was the art of Japan in particular that informed much of the stained glass of the Arts and Crafts Movement of which Morris could be said to be the prime mover.

The east window of the church is a stunning example of the genius and skill of the Morris workshop.

The panels facing, both from the east window, show St George and the Pelican in her Piety. The pelican, feeding her young with drops of blood from her breast is said to represent Christ sacrificing himself to redeem mankind.

On this page is one of the story windows from the aisle. The vicar of St Martin's was a friend of the artist and in his account book Burne-Jones jokingly wrote that the window was '... hastily estimated in a moment of generous friendship for £200 ...'

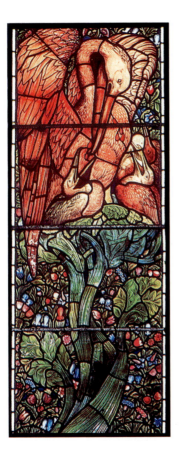
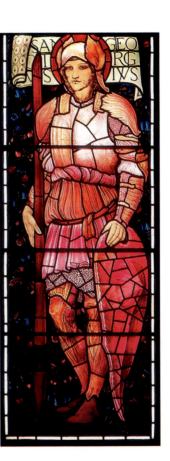

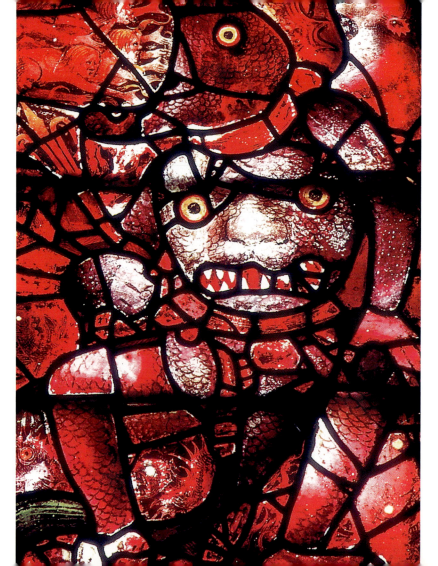

HELL MOUTH

❖

Fairford, Gloucestershire

S t Mary's Church in the village of Fairford contains what is probably the most complete set of medieval stained-glass windows in England.

Most remarkable in my opinion is the west window which shows Christ sitting in judgement on the last day as the saved ascend to glory and the doomed are thrust down to hell.

The glaziers working on the window seem to have been allowed a fairly free rein because they depicted hell as a glass-blowers workshop. In the detail opposite you

see the damned vanishing down the mouth of a monster with the head of a fish and a further monstrous head sprouting from its belly. This second head, often seen in the iconography of the Middle Ages represents the deadly sin of lust. As Chaucer's Pardoner preaches:

'Oh womb! Oh bely!
Oh stinking cod,
Fulfild of dounge and of
corrupcioun!'

The panel on this page shows little blue and red devils harrying sinners and carrying off the damned to their eternal and no doubt well deserved doom.

CAPTAIN OATES WINDOW

❖

Binton, Warwickshire

For a time the Reverend Lloyd Bruce was the rector of the parish of St Peter's, Binton, a small village lying to the west of Stratford-upon-Avon. His brother-in-law, Captain Titus Oates accompanied Captain Robert Scott on his last tragic expedition

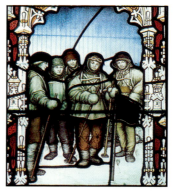

to the Antarctic and visited the rector on the eve of his journey to the South Pole in 1912.

As every English schoolchild knows, when food was running out and rescue seemed impossible, Captain Oates, who was ill and possibly dying anyway,

decided that if he was not to be a burden on the company they might stand a slim chance of surviving until they were rescued.

He went out into a blizzard saying, 'I am just going outside and I may be some time.' His body was never recovered. The fine set of windows in St Peters, made by Charles E. Kempe, commemorate the expedition and Captain Oates' self-sacrifice.

The panel opposite shows the Captain walking away into the bleak wastes to a certain and terrible death.

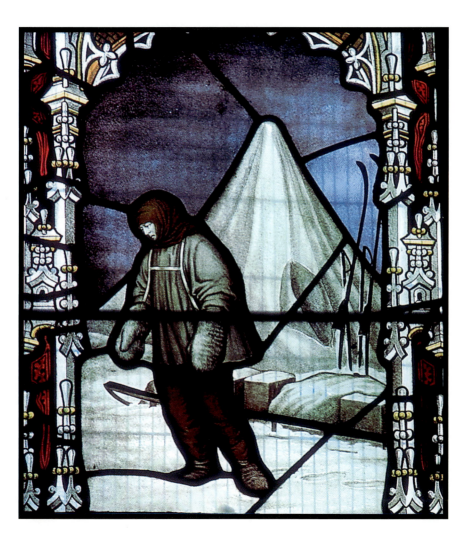

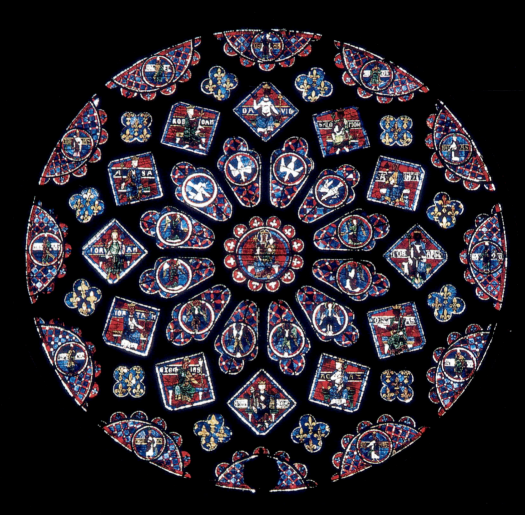

Rose Windows

❖

Chartres, France & York Minster

Many thousands of words have been written on the stained glass of Chartres, but nothing prepares you for the inspired majesty of the glass in that great cathedral.

Like many French cathedrals, Chartres is a vast, dark cavern, but set into its walls are the great jewels of its wonderful stained-glass windows.

The rose windows on these pages trace their origins back beyond the Gospels to the Wheel of Life, or the Sun Wheel, an image common to Buddhism and Hinduism, representing not just the sun but eternal truth.

The mandala, an abstract image that acts as a focus for meditation, found its way into Christianity as the rose window. The details are indecipherable from ground level with the naked eye, for the overall effect was intended to be both symbolic and meditative.

The window on this page is from the south transept of York Minster and was reconstructed after the disastrous fire of 1984. The rays of the sun streak in flashes of gold out from the blue hearted sunflower at its centre in more than 7,000 pieces of lustrous, many-hued glass.

CATHEDRAL BUILDERS

❖

Lichfield Cathedral, Staffordshire

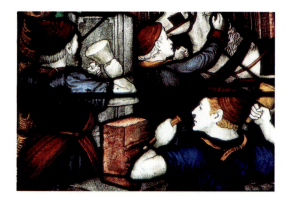

A fascinating series of windows from the nineteenth century shows builders at work on the cathedral under the command of Bishop Hackett who began a major reconstruction of the cathedral in 1662. Fairly accurate representations, they give us some idea of the planning and co-operation necessary to construct the great cathedrals of Europe, though all the workers look much cleaner and neater than I suspect they actually were.

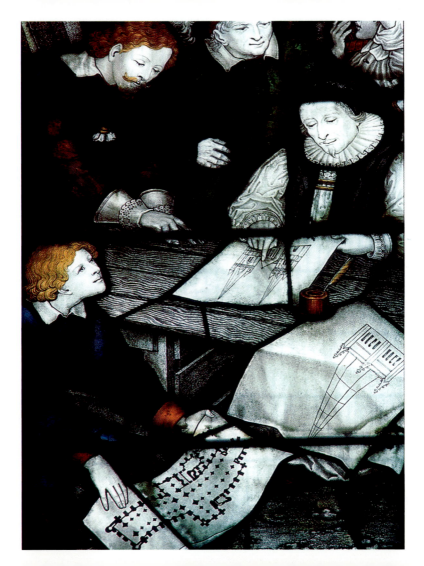

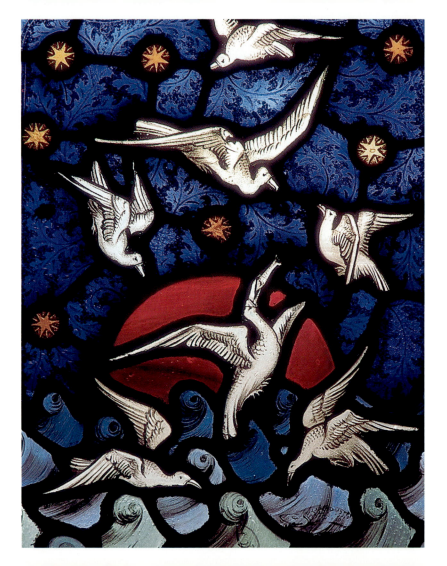

THE WATER WINDOWS

❖

Gloucester Cathedral

John Hardman of Birmingham originally worked in metal and enamels and was encouraged to branch out into stained glass by the great Victorian architect Pugin. Pugin himself designed many of the windows made by the Hardman workshop, and set a house style that continued after his death.

The window opposite from the lavatorium of Gloucester Cathedral depicts the separation of the water from the earth at the Creation and shows Hardman at his very best. The luscious colours are stunning even on dull days, and it is one of the finest examples of Victorian glass in the country.

The unifying theme in the lavatorium at Gloucester is, as you might expect, that of water, from the scene opposite showing the waters moving upon the Earth on the day of Creation to New Testament story of the miraculous draught of fishes. Close by the Creation window is the lovely piece above showing the brook of Sidon flowing through the Garden of Eden.

THE FISHES & THE PHOENIX

❖

Tunstall, Lancashire

St John the Baptist, the tiny parish church of Tunstall near Kirkby Lonsdale, has two fine sets of windows, surprisingly rich for such a small and quiet village.

In the east window are early fifteenth and sixteenth panels that

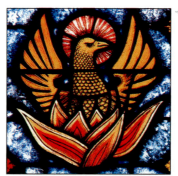

are Netherlandish in style, while in the south wall there is a modern memorial window by Jane Grey made in 1979. Unlike much modern stained glass, the window is not abstract but symbolic and is, to my mind, a fine example of

the very best of contemporary design.

The intertwined fishes representing both Christianity itself and its root core, the Trinity, swirl and turn on a rich field of blues studded with the red roses of Lancashire.

The phoenix above, a symbol of Christ's resurrection after death, burns fiercely when the sun catches it and when the sun is low in winter and flickers through the trees, the flames seem to toss and move.

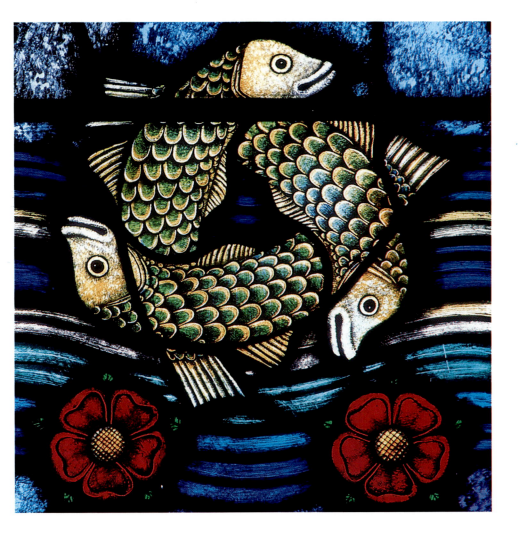

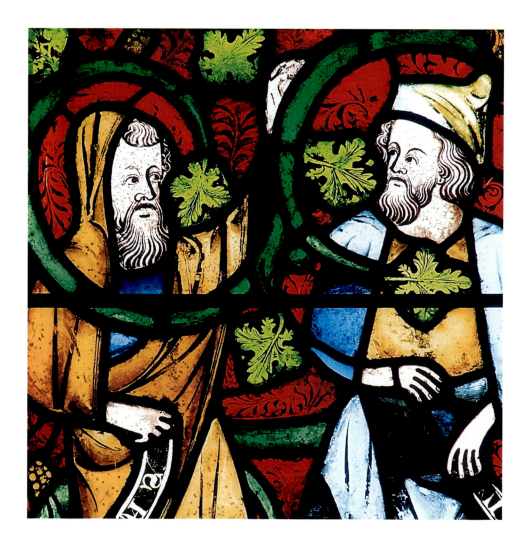

Jesse Trees

❖

Cartmel Priory & York Minster

Jesus traced his line of descent from Jesse, father of David, in fulfilment of the Old Testament prophesy:

And there shall come forth a rod out of the stem of Jesse, and a branch shall grow out of his roots: And the spirit of the Lord shall rest upon him

– Isaiah 11:1–2

The Jesse Tree, the family tree of Jesus, is a favourite subject of glass painters, the inter-weaving branches giving them plenty of scope for decoration and ornamentation and moreover giving a common theme to

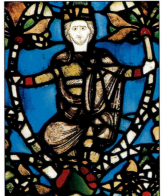

the whole window. Chartres and St Denis both have superb Jesse windows and the glass on this page is a fragment of a twelfth-century window in York so similar to the French windows that it is possible that it came from the same workshop.

The Priory Church at Cartmel has several delicious fragments of a Jesse Tree destroyed by iconoclasts. The piece opposite is to my way of thinking one of the finest remnants in the church and a sad indication of what beauty has been lost.

Paintings into Glass

Wensley, North Yorkshire & Kirkby Malham, Yorkshire

Wensley's Church of the Holy Trinity in the Yorkshire Dales has the window opposite set into its west wall. Derived from Holman Hunt's fine painting *The Light of the World,* the window contains such rich and luscious glass that it stands in danger of becoming almost decadent. The picture captured the public's imagination to such an extent that it was reproduced in vast numbers in the late Victorian period.

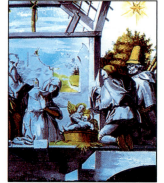

The Nativity scene on this page comes from the church of St Michael's, Kirkby Malham. The church has a number of interesting features including two primitive Celtic heads, but by far the most interesting of all is this small pane of glass that can be found close to the altar. Nobody seems to know how it found its way into this tiny church in the Yorkshire Dales but it is said to be based on an etching of the nativity by Albrecht Dürer, the sixteenth-century German artist. The dress of the men and women certainly suggests that the window is either north German or Low Countries in origin.

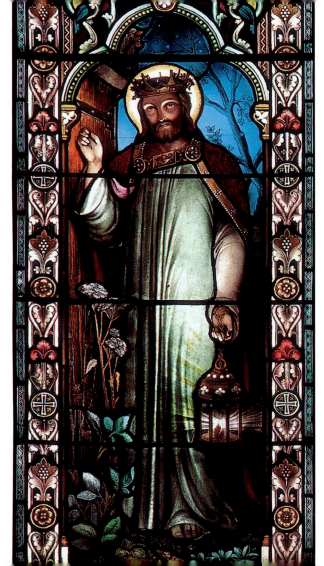

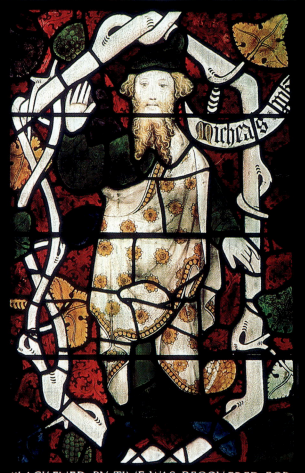

BLACKENED BY TIME WAS RECOVERED FOR
MANY WYKEHAMISTS: THE FIGURE OF JOASH IS

Fourteenth-Century Saints

Winchester College Chapel

Winchester College has a lovely chapel, overshadowed by its prestigious and better known neighbour, the cathedral, but the chapel is well worth visiting because it contains some very fine misericords and some beautiful glass.

The east window is a modern reconstruction of a Jesse

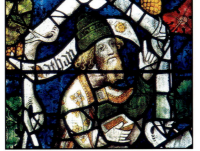

Tree made in 1822 by Betton and Evans. The real gem of the chapel, however, lies in the west window of Thurbern's chantry. The original medieval glass of the great east window was removed to Ettington in Warwickshire by the Victorian restorers of the chapel. Thankfully, part of the window, a group of medieval panels signed by the glass-painter Master Thomas of Oxford and dating from the fourteenth century found their way back into the chantry in 1951.

On these pages the branches of the medieval Jesse Tree intertwine their way around the window panels, framing the saints. The faces within the panels are great studies in character, while the detail of the clothing gives us a good idea of medieval daily wear.

HARRY CLARKE WINDOWS

❖

Sturminster, Dorset & Tullycross, Co. Galway, Ireland

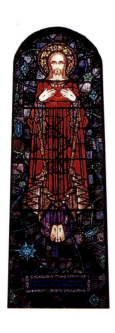

Born Henry Patrick Clarke in Dublin of a Yorkshire father and a Sligo mother, on St Patrick's Day 1889, Harry Clarke was to become one of the most inspired and imitated illustrators, designers and glass-makers of this century.

The children's books he illustrated are now collector's items and his stained-glass windows which can be found both in Ireland and in England are stunningly beautiful.

The influence of Beardsley, whose work Clarke studied as a young man, is clear to be seen, but Clarke's work always stays this side of the degenerate. The luscious colours and the sweeping lines of his windows are simply joyous.

The panels opposite from Sturminster, Newton, show St Margaret, the Virgin; and a kneeling knight, the panel on this page from Tullycross depicts the newly risen Christ showing his wounds to the World.

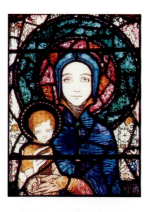

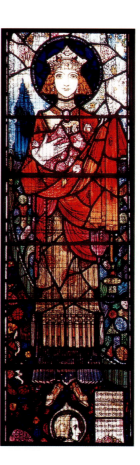

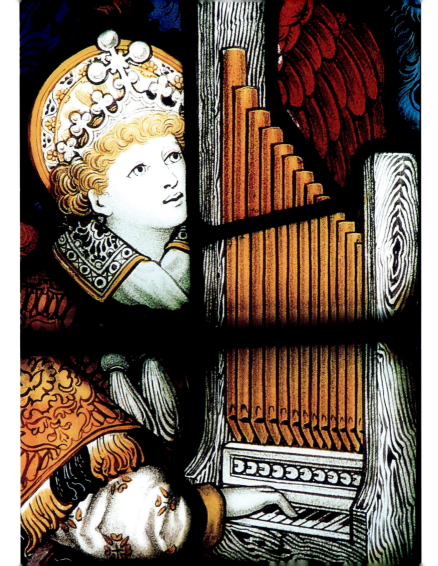

Angel Musicians

Lichfield, Staffordshire

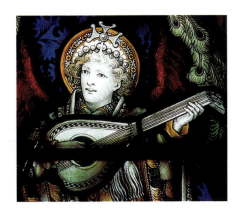

Two angel musicians in the eighteenth-century windows of Lichfield Cathedral.

The glass-painters' art is still evident and the delicacy of touch in both the peacock feathers in the picture of the lute player and the golden curls of the portative player are wonderful examples of the standard that the Dutch school of artists who painted Lichfield had achieved.

A portative is a small portable hand-pumped organ, very sweet in tone, well suited to early English church music.

DEVILS & DEMONS

❖

Gloucester Cathedral & Martham, Norfolk

Satan and his legions figured large in the art of the Middle Ages. Visions of doom, the Last Judgement and hell's mouth gaping wide open were all part of the wall paintings and stained-glass windows of many of Europe's ancient churches and cathedrals.

Winged and horned, the swarming devils and demons usher lost souls towards hell and gleefully help St Michael to weigh the souls of those to be judged on the Last Day. The picture opposite, from the tiny parish church in Martham, shows two particularly chubby demons, representing the sins of the damned. They are obviously having a great time tipping the scales against the poor lost sinners in the other pan.

Satan shaking his fist on this page, from the cloisters of Gloucester Cathedral, is cursing Christ who has spurned his temptations during his forty-day fast in the desert.

The late Victorians eschewed wings and horns in favour of a more human-looking demon which makes him less monstrous but somehow much more evil and sinister.

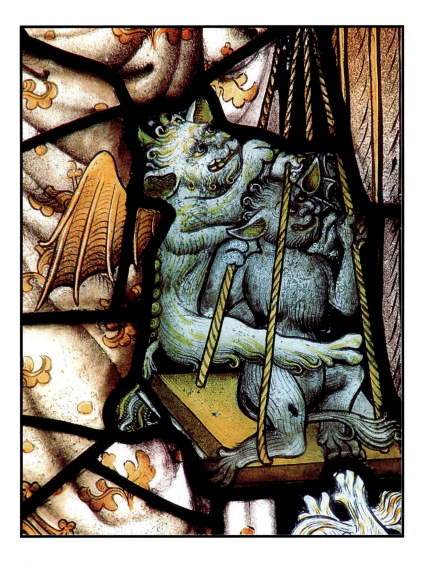

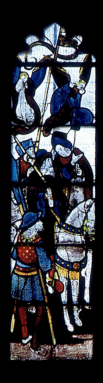
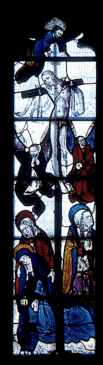
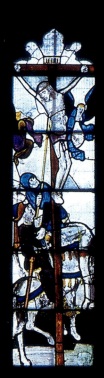
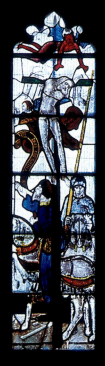
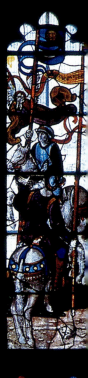

CRUCIFIXION SCENES

❖

Fairford, Gloucestershire
& Cartmel Fell, Lancashire

High on Cartmel Fell, a tree-rich haven on the fringes of the Lake District, is the small but beautiful church of St Anthony.

The east window contains a lovely fifteenth-century Crucifixion (this page) that came originally from Cartmel Priory. Based on a painting of the Seven Sacraments by Rogier van der Weyden, Flanders 1430, the window has suffered greatly from the attentions of various men of religion over the years but still has much of its original glass.

Opposite, from St Mary's, Fairford, a beautiful unspoilt medieval window shows the scene at Golgotha with Jesus between the two thieves and soldiers lancing the sides of the dying Christ, all a riot of colour and movement.

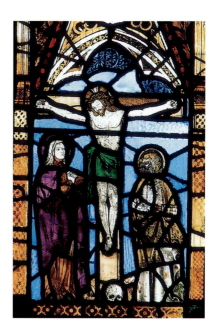

St Andrew & St Agnes

Gloucester Cathedral & Greystoke, Cumbria

Once a collegiate church, Greystoke is now a lively parish centre which, as well as containing some quite excellent misericords, also has one of the most complete medieval east windows in England.

It is said that the people of the parish, having heard that Cromwell was on his way to destroy the glass, dismantled the window and buried it. It was reassembled after the Commonwealth and repaired again in 1887; almost the whole of the St Andrew window is the original medieval glass.

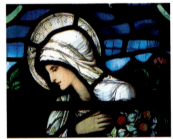

St Agnes on this page comes from a delightful set of panels in the cloisters of the cathedral at Gloucester. Crafted in the William Morris workshops, it was commissioned to replace a damaged window that was removed in 1924.

Like all the best glass from the Morris workshop, the panels are a marvellous combination of well-defined line and deeply saturated colour. Though Morris came late to the Pre-Raphaelite brotherhood, the influence of that movement on the panels in Gloucester Cathedral can clearly be seen.

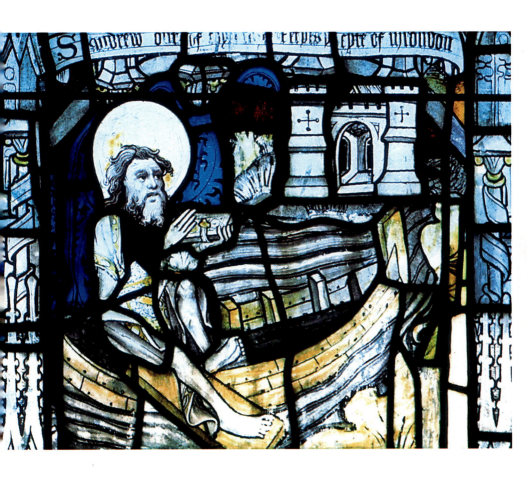

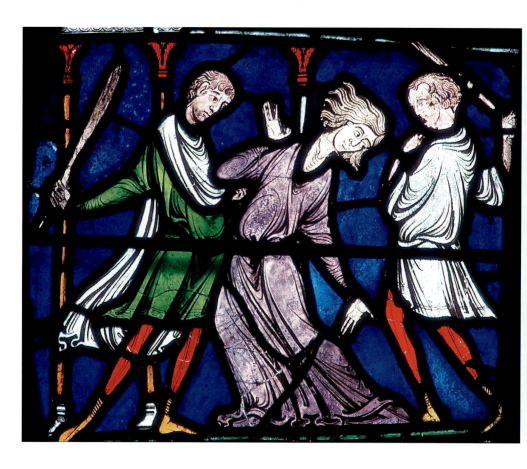

THE LUNATIC & THE LEPER

❖

Canterbury Cathedral

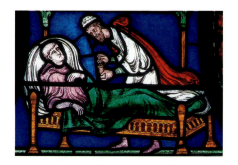

Canterbury Cathedral is blessed with some of the finest stained glass in Europe. One set, in the east end of the building shows the miracles of St Thomas à Becket.

After his martyrdom many cures were attributed to him, including that of mad Mathilda of Cologne who had committed a murder. In one of her moments of sanity she received a vision of St Thomas and set off on a pilgrimage to Canterbury, where she was cured. Here she is shown being birched, which was thought in those days to be a cure for madness.

The panel on this page shows Elias of Reading, a leper who was also cured by St Thomas. A doctor is looking at a flask of his urine, a standard procedure in medieval medicine.

THE OWL & THE WREN

❖

York Minster

Much of the great glass in the Minster at York is high above the nave and quite difficult to see without a pair of binoculars. The glass in the lovely Zouche Chapel however is almost at eye level and a number of quarries (small panes of glass) contain quite crude, but often lively or humorous paintings of animals and birds.

My particular favourites are the owl with the mouse in its claws perched on a spray of acorns and oak leaves (this page) and the wren about to attack a spider in its web (opposite).

The bird and spider are sketched so vibrantly that, every time I look at the window, I am reminded of the drawings of Ronald Searle, the English cartoonist.

Michael Camille's book, *Image on the Edge*, points out how the often subversive paintings and carvings that appear in the margins of medieval glass and books and on the exteriors of the great cathedrals owe much to the spirit of carnival, that upside-down world where licence of all kind is permitted.

We in the modern world find it hard to understand how, in the Middle Ages, the burlesque and the bawdy could appear in church art. The medieval mind had no such problem.

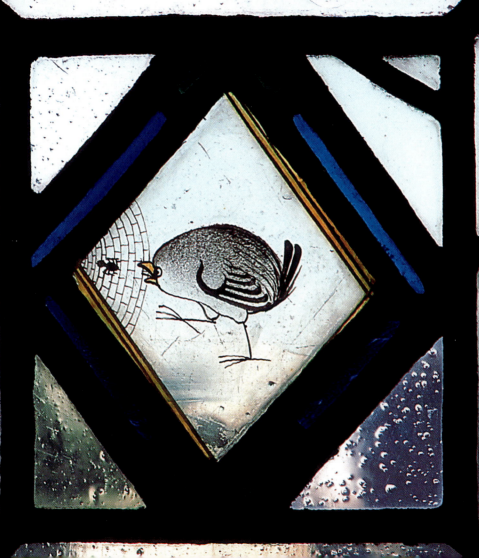

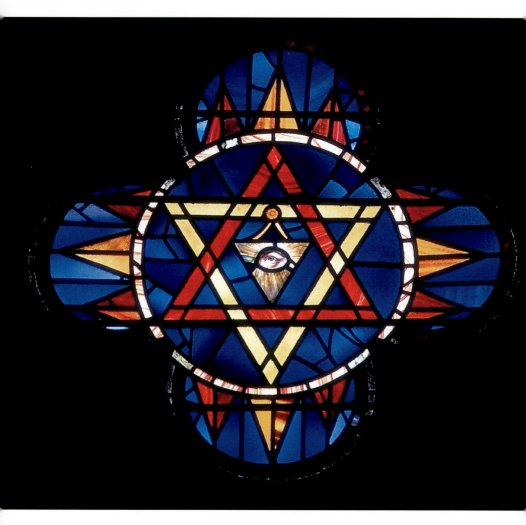

THE WORLD OF SYMBOLS

York Minster & All Saints, York

We are no longer able to see the world as the medieval peasant might have seen it. What concept can we have of a world lit only by candlelight and peopled with unicorns, dragons and demons? This is not to imply that the people of the Middle Ages were in any way stupid or uncouth, simply that they had their own mythology and cosmology.

Symbols were as important to the medieval peasant as they are to present day Buddhist monks and I would venture to suggest that many medieval symbols served the same function that mandalas do today: they were a focus towards which the mind could be directed in worship and meditation. The Seal of Solomon with the central eye is a wonderful piece of modern glass in the nave of York Minster that contains two most important elements of medieval iconography: the eye within the seal, one of the oldest alchemical and mystical symbols of all, symbolizing all the elements of earth, air, fire and water, combined with the three (the triangle) to produce the magic number seven.

The lovely sun and stars on this page come from the Pryke of Conscience window in All Saints, York.

Landscape into Art

Tunstall, Lancashire & All Saints, York

Early stained glass, like early paintings, made no attempt to set the subject in any kind of broader scene. Thus the earliest images of the Virgin and child are simple icons in which the background is either black or a thin patina of gold leaf.

It was only later, after the Italian painters had introduced landscape into their paintings of such subjects as the Nativity and St Jerome in the wilderness, that the exterior world started to feature in the art of

the Middle Ages. The glass on the facing page from St John's, Tunstall is a detail from the east window. Cypress trees and hills in the distance form a back-ground against which the spires and towers of a Italianate town are clearly seen. Perhaps the window was inspired by an early Italian painting. The crudely realized but endearing trees and blades of grass on this page are from a panel in the Pryke of Conscience window in All Saints (see pp. 52–55).

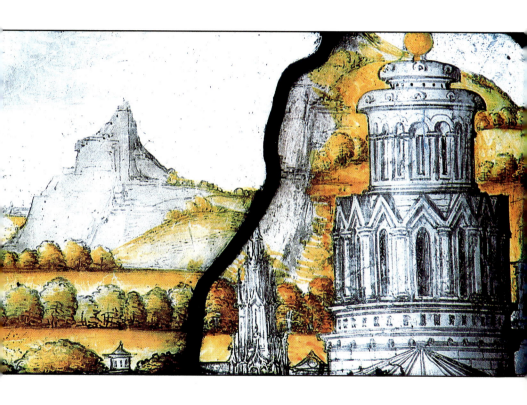

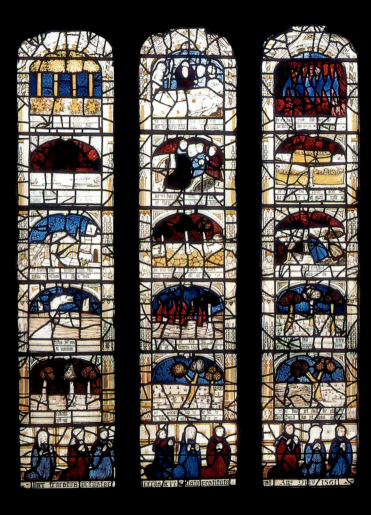

PRYKE OF CONSCIENCE

❖

All Saints, York

Without doubt one of the greatest stained glass windows in the world, the lovely Pryke of Conscience window lies in the north wall of All Saints Church in a quiet riverside street well away from the noise, bustle and rush of the medieval city of York.

The window depicts the last fifteen days at the end of the world, when doom and judgement will be brought upon us all. Amongst the many things that happen on that day: the sea rises and falls, the trees catch fire, human bones come to life, sea monsters appear, stars fall from heaven, death comes to drag men to their graves (the detail below) and fire consumes the world.

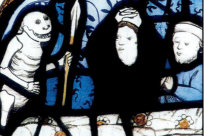

Experts believe that the window was made *circa* 1410 by John Thornton, the master glazier who also created the finest of York Minster's medieval glass.

On the following two pages you can see the dead bones coming back to life and the trees catching fire, but no mere pictures can show the true wonder and glory of the window.

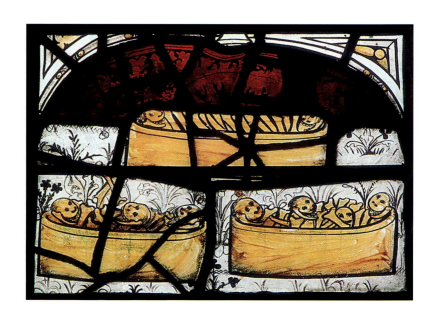

Dead bones come back to life

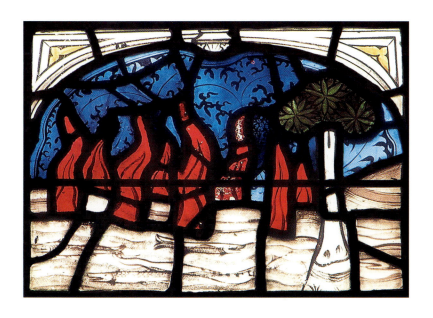

The trees catch fire

Izaak Walton Window

❖

Winchester Cathedral

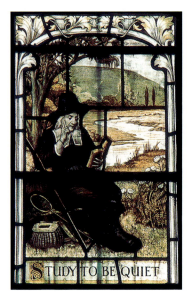

Izaak Walton (1593–1683), the author of *The Compleat Angler,* spent the last two decades of his life in Winchester and is buried in the cathedral. In gratitude for his writings on things piscatorial, in 1914 the fishermen of England and America paid for a memorial window to be made showing scenes from the Compleat Angler's life.

In the panel on this page he is shown reading quietly beside the River Itchen, a famous Hampshire chalk stream renowned for its shy and elusive trout. On the facing page Walton and Charles Cotton, his companion on many of his fishing trips, are shown amongst the limestone crags of Derbyshire. The river flowing behind them is most probably the Dove, the dale therefore being that most beautiful of dales, Dovedale.

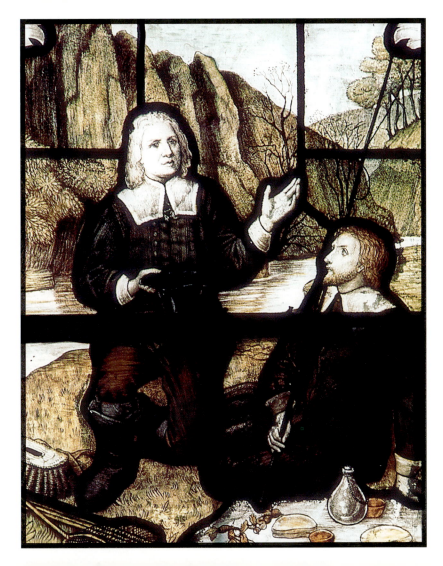

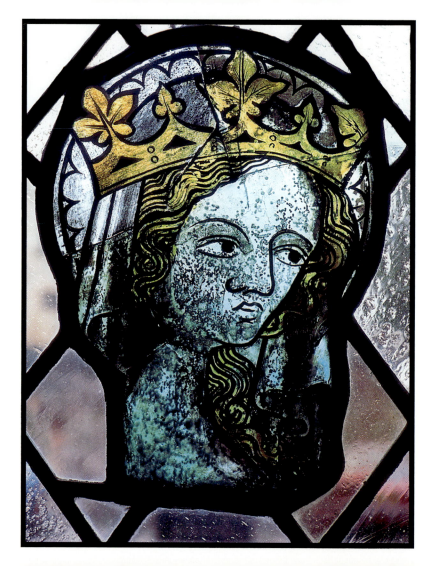

FOURTEENTH-CENTURY VIRGINS

❖

Bristol Cathedral & Edington, Wiltshire

Mary, the virgin mother of God, was venerated in the Middle Ages above all other saints, so much so that historians now speak of the 'cult of the Virgin'.

This veneration may have had two prime sources. The rise of strong kings across medieval Europe was echoed by the notion of queenship. The royal line therefore could only come from women who were both strong, pure and faultless. More basically, perhaps, the cult was an echo of the worship of what we now call the earth mother, the goddess figure who dominated the pagan pantheon and thus May, the first month of summer became the month of Mary and on May Day across Europe the May Queen, would be wedded to the Green Man, the ancient fertility icon of pre-Christian Europe.

The cult of the Virgin intensified after the Church declared that Mary was conceived without stain of original sin (the doctrine of the Immaculate Conception) and that, rather than suffering death and decay, she was taken directly to heaven (the Assumption). The image above is a lovely simple panel in the little church of Edington; the head opposite is from a set of panels in the cloisters at Bristol.

Mad Hatter & Dormouse

❖

Daresbury, Cheshire

Charles Lutwidge Dodgson, otherwise known to the world as Lewis Carroll, was born in the parsonage of the little Victorian church of All Saints, Daresbury, on January 27 1832. His father was incumbent there from 1827 to 1843, and the young Charles Dodgson spent his formative years roaming the fields and lanes of the village.

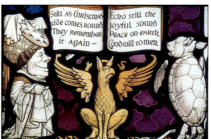

Perhaps the gentle and soft landscape around the village was the setting for the bank on which Alice sits before travelling down the rabbit hole to begin her surreal adventures in Wonderland. To mark the centenary of Lewis Carroll's birth, a truly wonderful set of windows, based on the Tenniel illustra-tions to the *Wonderland* and *Looking Glass* books, was built into the east end of the church and funded by subscriptions from all over the world. Above you see the Queen of Hearts, the Gryphon and the Mock Turtle. The facing page shows a scene from the Mad Hatter's Tea Party.

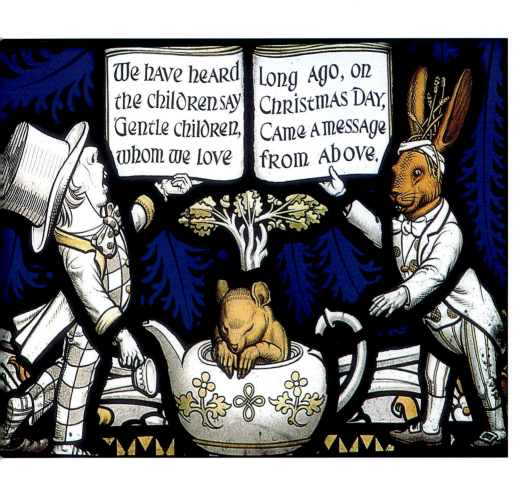

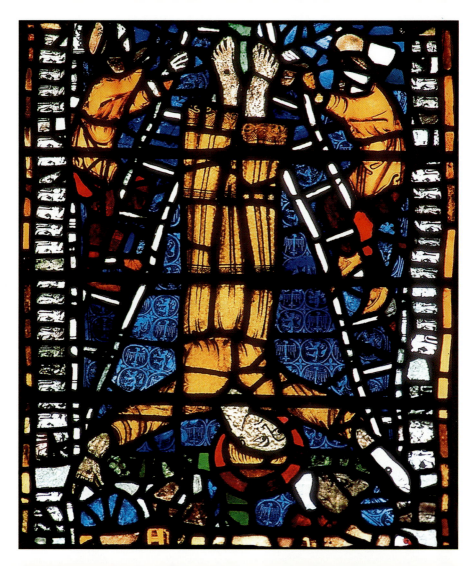

MEDIEVAL TO MODERN

❖

York Minster

Y ork Minster and the many medieval churches of that city contain a wealth of stained glass unparalleled outside mainland Europe.

The medieval windows in the north aisle of the nave in particular contain a treasury of glass that shows the influence of the great French glass-makers who created the coloured walls of Chartres and Saint Denis. Bibles in coloured glass, they have been beautifully repaired and conserved by the skilled and dedicated glass-makers of York this century. Opposite, a panel shows St Peter being crucified upside down.

There is some modern glass in the Minster, the best, in my opinion, the window by Ervin Bossanyi (1891–1975) in the Zouche Chapel showing scenes from the life of St Francis of Assisi. Bossanyi was a Hungarian glass-maker whose stained glass can now be seen all over the world from Washington, DC in America to Canterbury Cathedral.

Mɑdonnɑ & Child

❖

Winchester College Chapel & Gloucester Cathedral

Mary, as the Madonna, the Virgin Mother, holding the infant Jesus in her arms, is possibly one of the most popular subjects of all with stained-glass painters. The image of the compassionate and suffering mother whose son was to die upon the cross fixed itself in the psyche of European Christians from the Middle Ages into this century.

The panel on this page from a fourteenth-century window shows Mary suckling her child and is a beautifully tender picture, though it is obvious from the structure that it has suffered quite a lot of damage. The injury done to images of the Virgin during the Reformation was nothing compared to the wholesale destruction carried out by the Cromwellians who had a hatred of any imagery or icons, seeing them not as a focus of worship but as idols. They had a special hatred for women who they compared to 'sacks of dung'.

The panel on the facing page is from the North Walk in the cloisters of Gloucester Cathedral and was made by Morris and Co. in 1924, a lovely example of that workshop's later work.

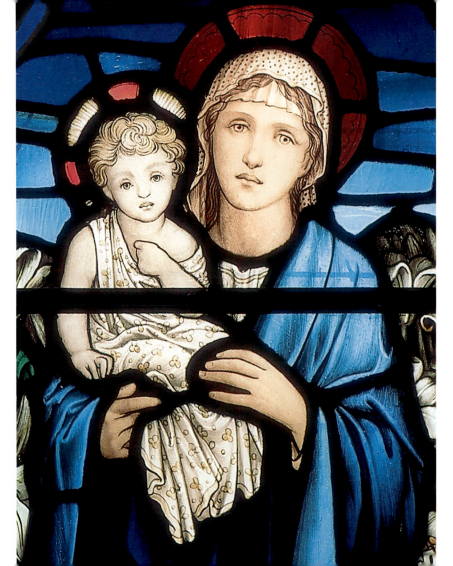

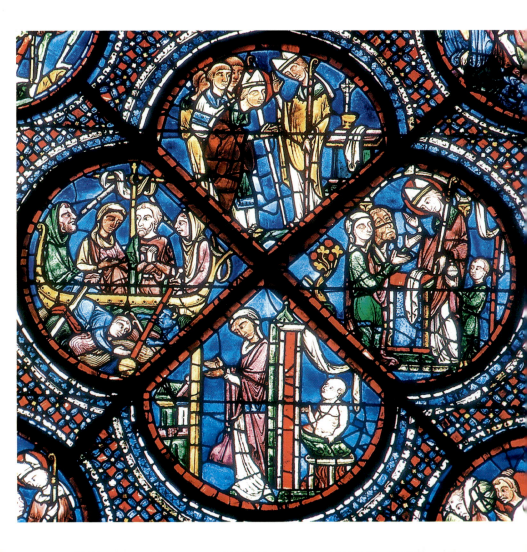

Music for the Eyes

Chartres, France

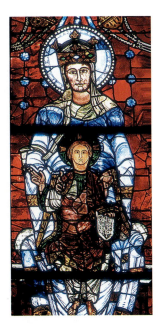

The great windows of Chartres must surely be amongs the artistic wonders of the world; they are the high point of medieval glass-making. So powerful was the effect of the glass of Chartres on the medieval mind that it came to be equated with alchemy and gave rise to a number of fables. The deep blue glass was said to have been made from ground-down sapphires while the ruby-red flashes were said to have been created by the addition of pure gold.

The window on this page is one of my personal favourites, the Virgin Mary in majesty with the infant Jesus on her knee, the blues and reds unsurpassed and the delicacy of the features burning out across the centuries. The roundels opposite echo the twelfth-century Abbot Suger's words: 'The pictures in the windows are primarily for the humble, who cannot read the Word, to show them what to believe.'

My thanks go to the Deans and Chapters of all the cathedrals whose treasures are featured in this book and likewise to all the vicars, vergers and enthusiastic helpers who gave me so much assistance. Draughty churches and chapels were opened for me and people went to great lengths to light my way in the darkness. Countless ladies gave me cups of coffee and tea and, with the exception of one man who is obviously unwell, I was shown nothing but kindness and courtesy by all those involved in the care and maintenance of the churches and cathedrals they so obviously love. I offer this book as my thanks to them and in praise of the men and women who created such great art to the glory of their God.

The photographs were taken using a Nikon F3 and 20mm, 35mm, 55mm macro, 200mm and 600mm telephoto lenses. The film used throughout was Fuji Velvia.

The Mad Hatter we see here, is from a set of Lewis Carroll panels (see pp. 60–61); the stained glass window opposite is from the author's studio, made by Abbots of Lancaster, depicting Macchapucchare, a sacred mountain in Nepal, and showing the way the author went on his first journey in that country.

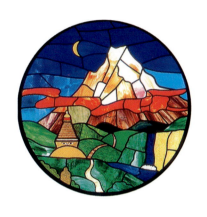

THE END